Colors Of My Feels

Hassan Abeida

Birth

*B*orn in September 1981

In city by the Mediterranean see call Benghazi

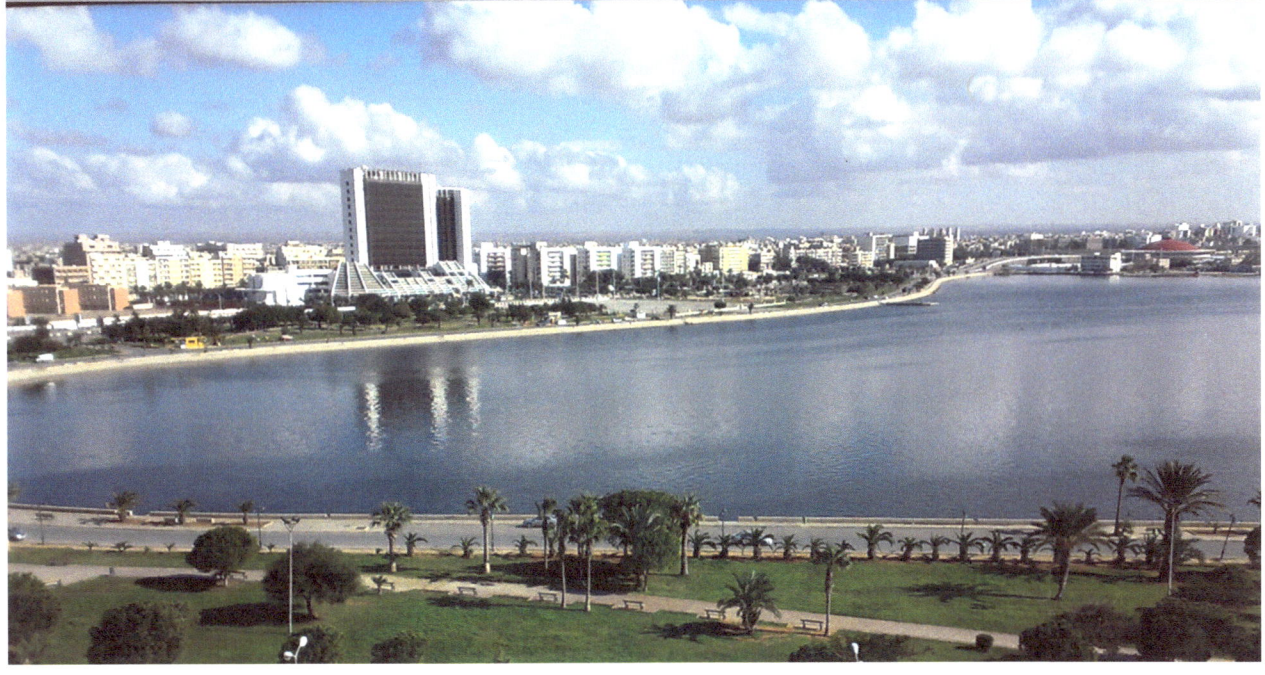

Home & Family

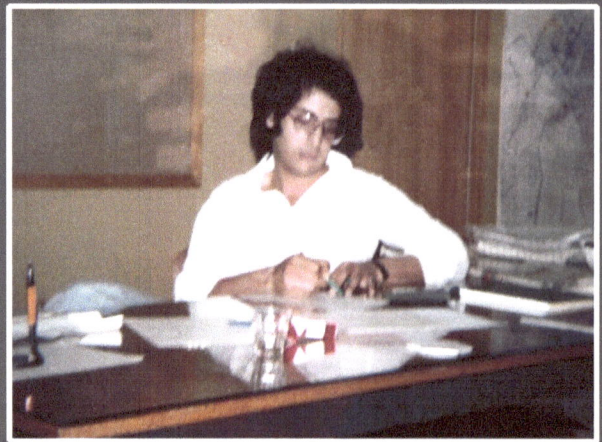

*His father is well known Libyan architect Mustafa Abeida ,
in the 70's and 80's was one of the key architects who plan and design
the modern face of Benghazi*

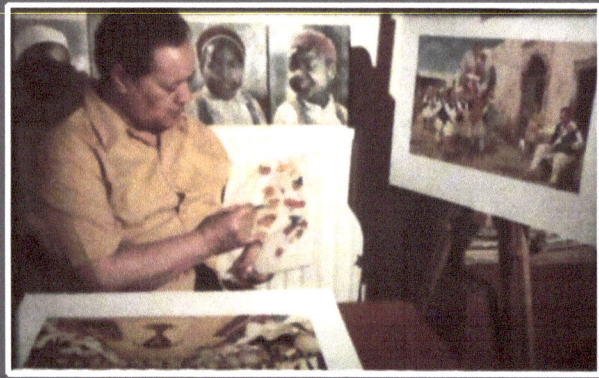

*The grand father
Artiest Awad Abeida , through his artwork he recorded
the history of LibyaSo he was known by Libyan as
The house of art & heritage*

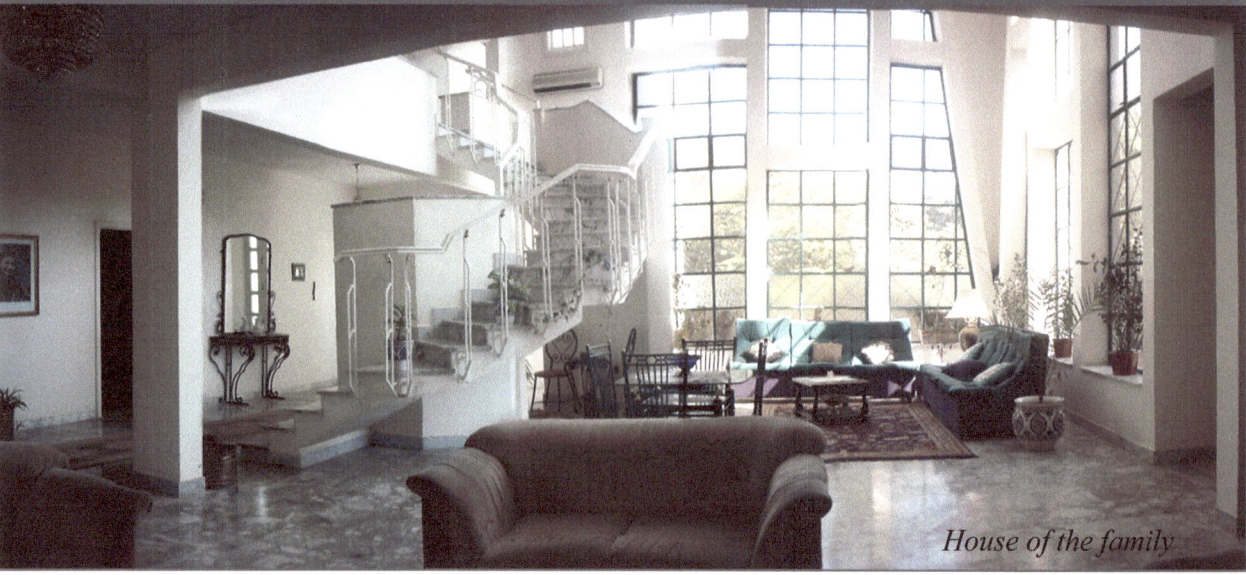

House of the family

Study & inspiration

Studied architecture and urban planning in university of Garyounis in his hometown

through the study years he created new type of expression to explain his designs and visions
the expression inspired by the motion of Arabic's text lines ,mixed with shades and depth of the prospective

Awarded international prize in sustainable design by Oxford brooks university and the royal institute of British architects , and after the graduation he awarded many honorable prizes in architecture design

In 2010 published his first book , the book about his design philosophy
The form and the function follow the main concept"

a) You are very hard working.
b) You have a natural flare for form and function
c) There is a spark of genius there....

Professor Sue Roaf
Heriot Watt University

Waves & changes

The city of Benghazi passed through a critical changes and still in this waves of changes

In early 90's the country passed through international isolation because of political of the regime , in the 2000's explosion of money and un planned mega scale of projects comes equal with big corruptions to the city

In 2011 rebellion against the regime started in this city end up with civil war and destroy the old and modern building to the ground

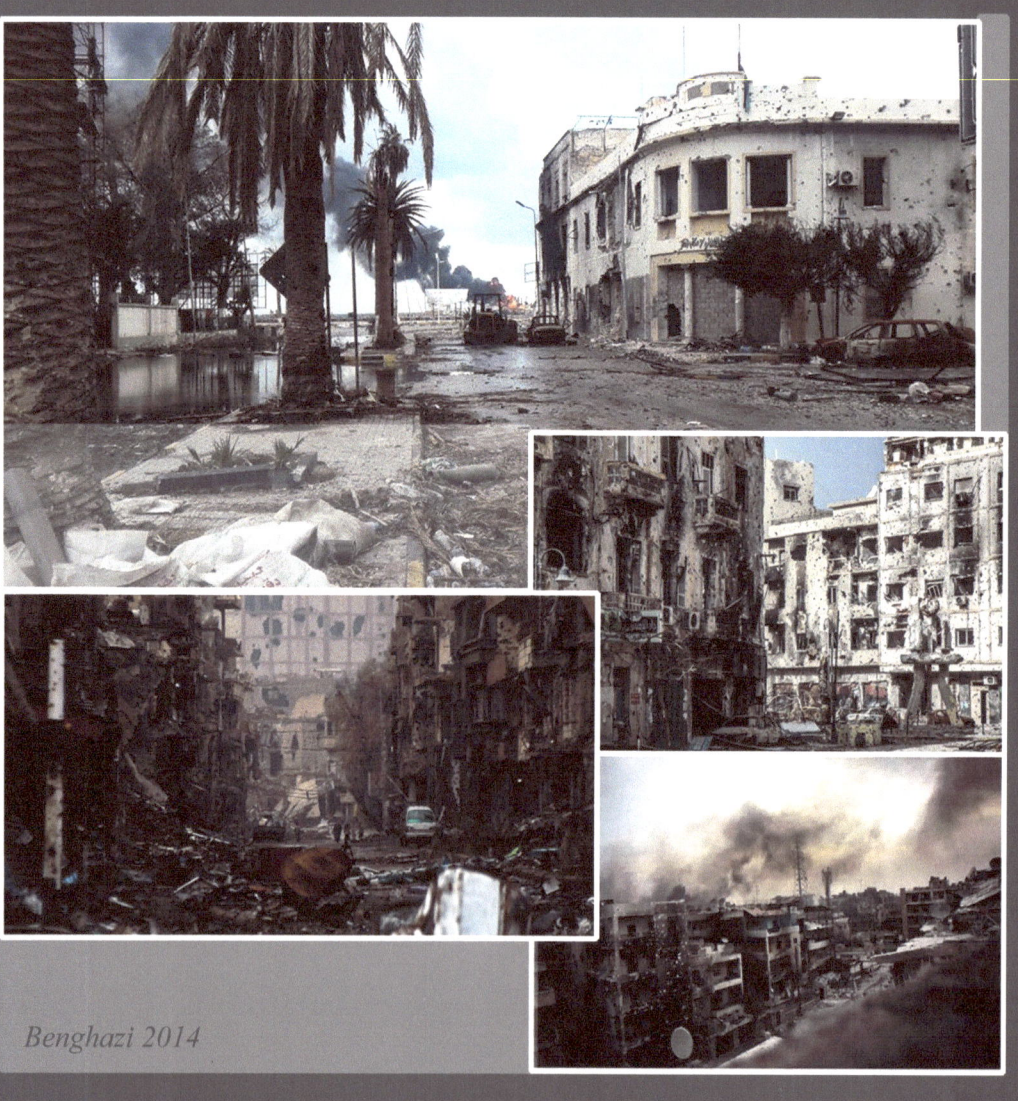

Benghazi 2014

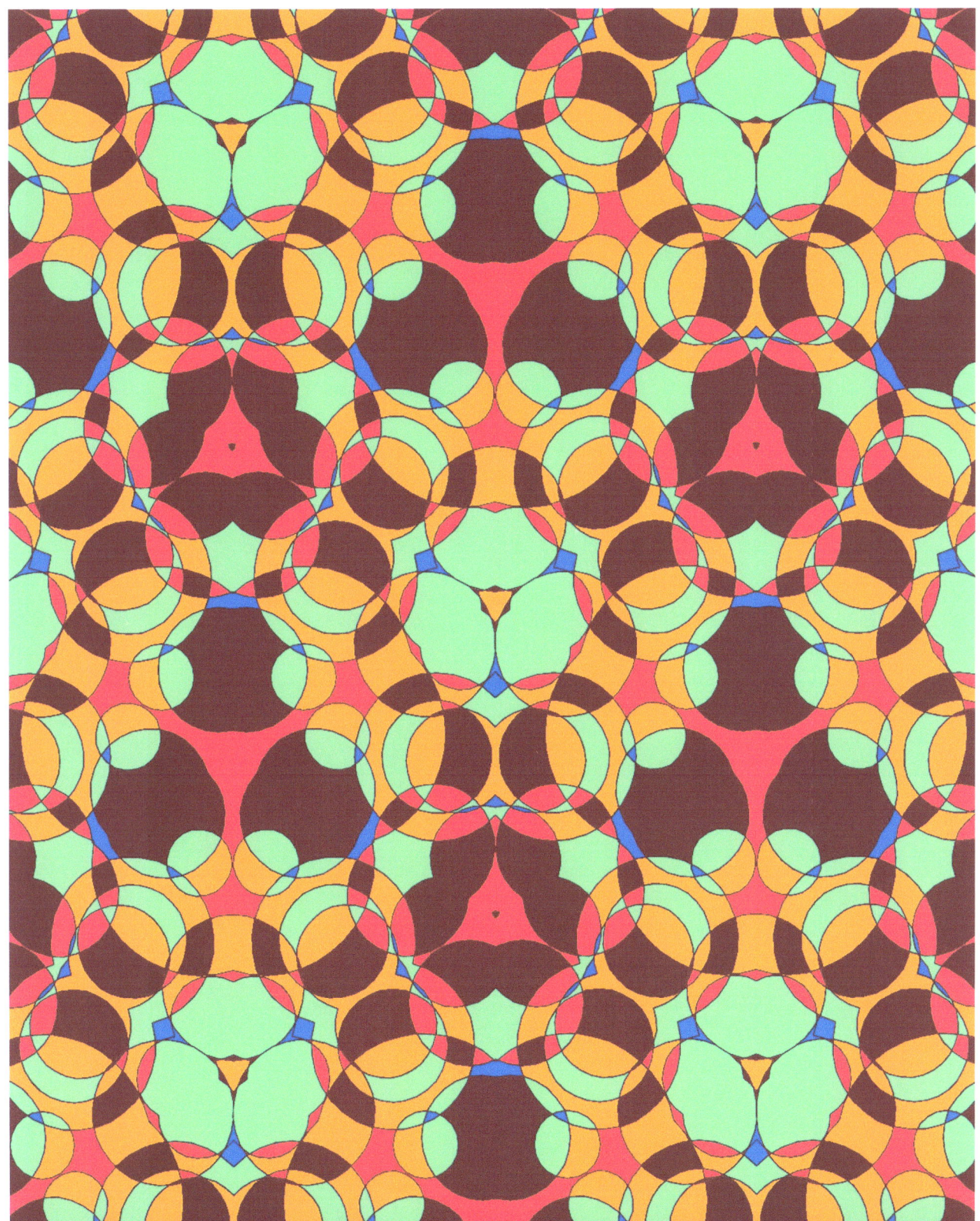

All this mixed with unique type of traditions , make some unstable and strange moments in his feelings , he released those feelings in type of colors and lines to deliver what
words can not describe
In this book you can only see timeframe of the weird moments of feeling in sort of lines & colors

Human Beings
4000 pixels x 4672 pixels
Needs ,Fears, Asks & More

Colors Of My Feels

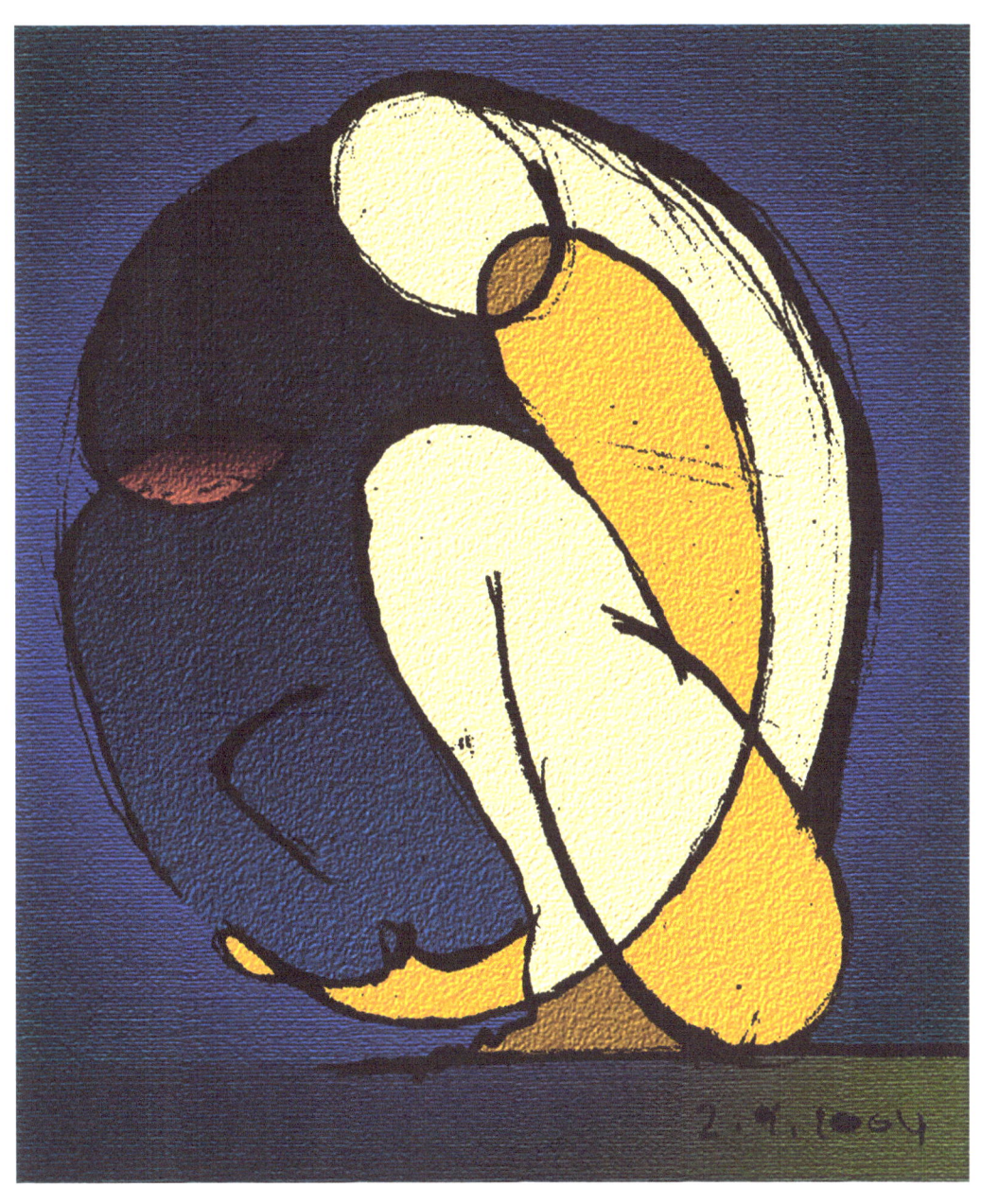

Hassan Abeida

Greed
2178 pixels x 1984 pixels

Colors Of My Feels

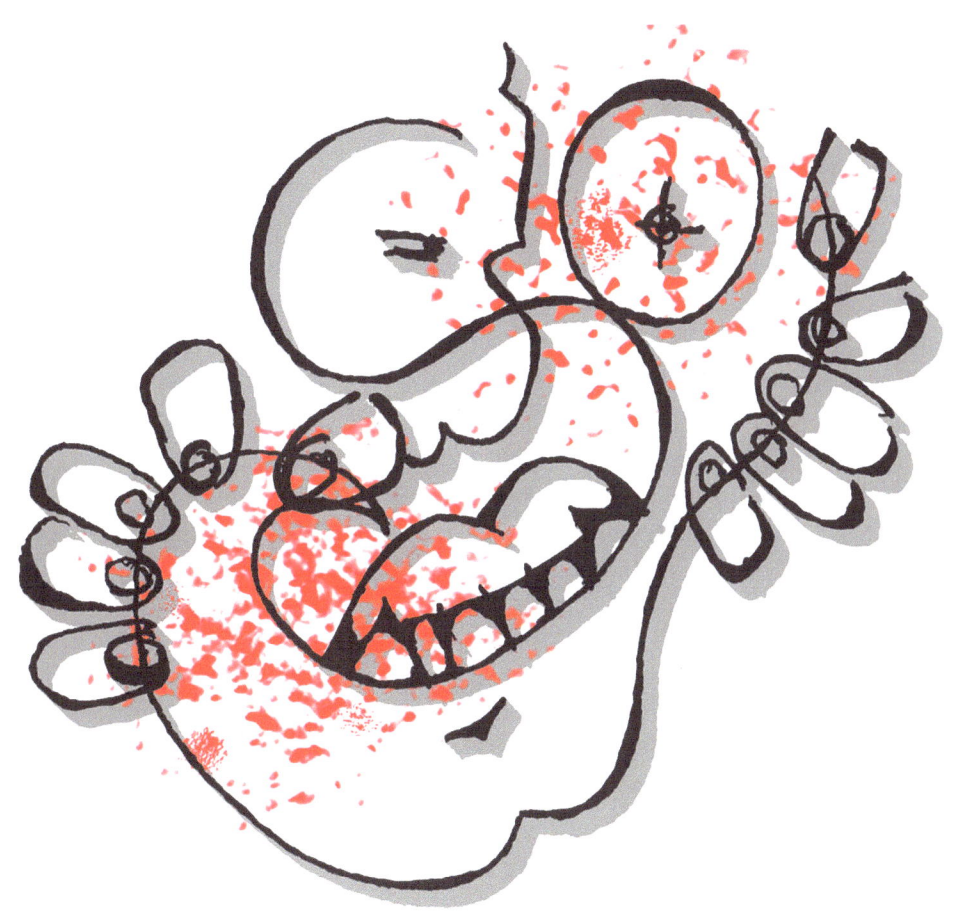

Hassan Abeida

Ice & Fire
4724 pixels x 5270pixels

Colors Of My Feels

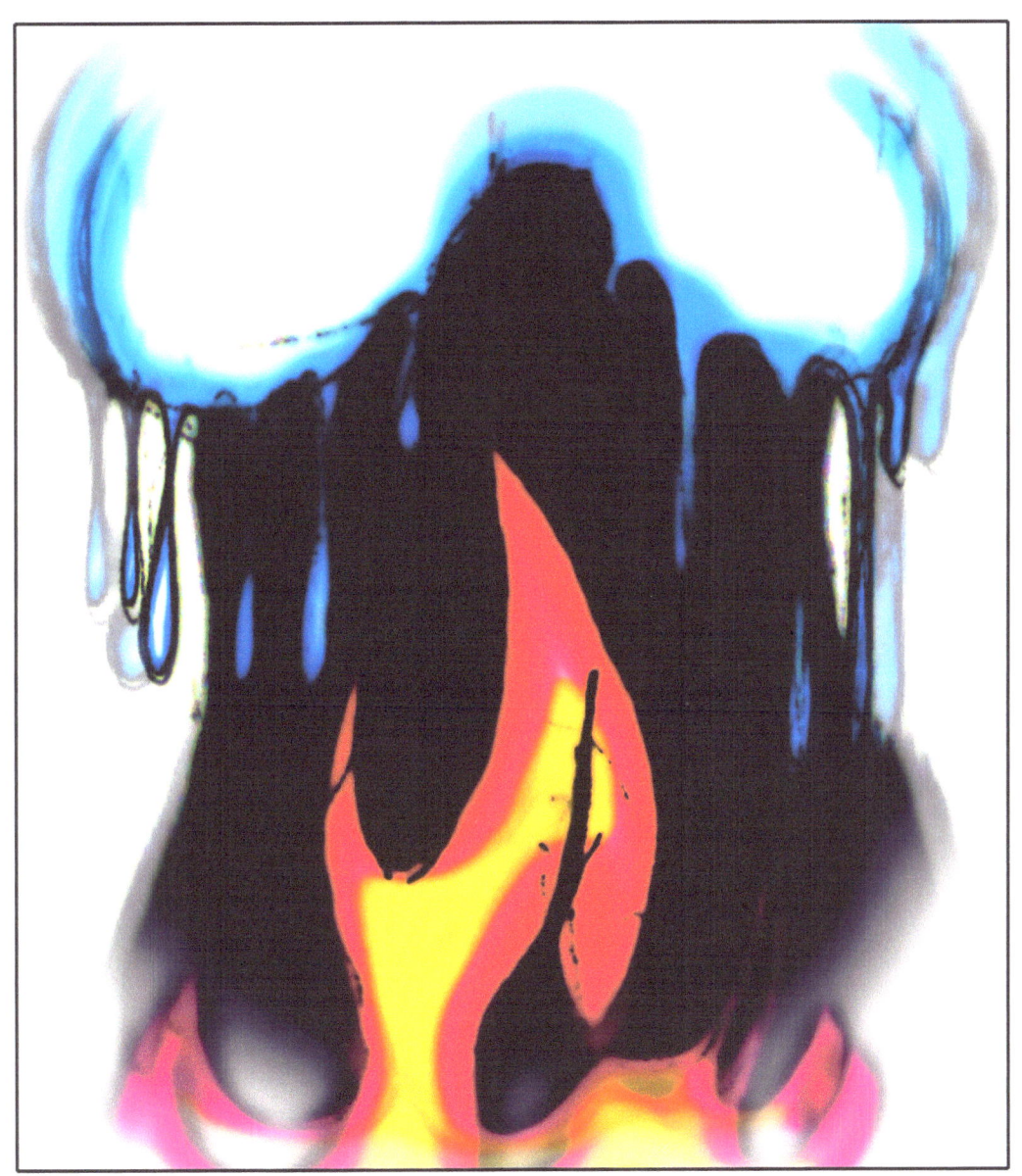

Hassan Abeida

Fear & Motherliness
1200 cm x 1730 cm

Colors Of My Feels

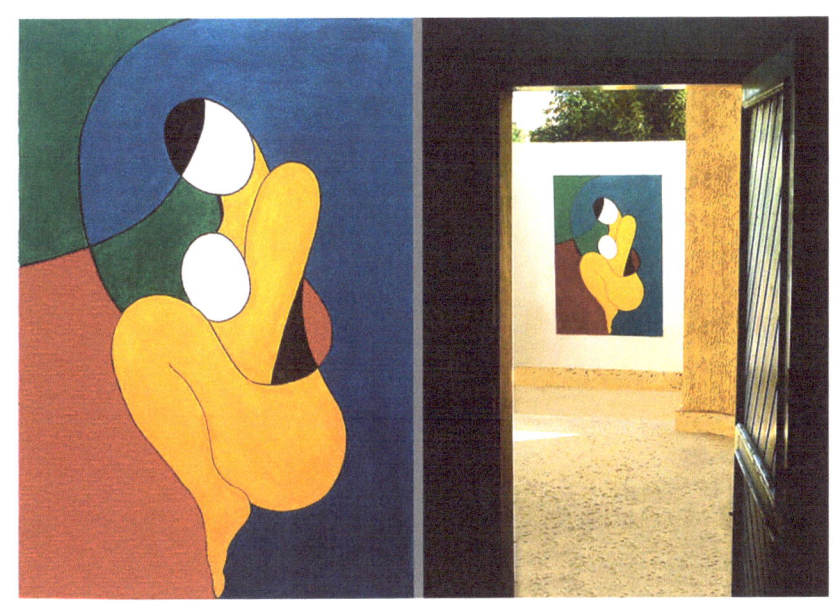

Hassan Abeida

It's Now !
3044 pixels x 2810 pixels

Colors Of My Feels

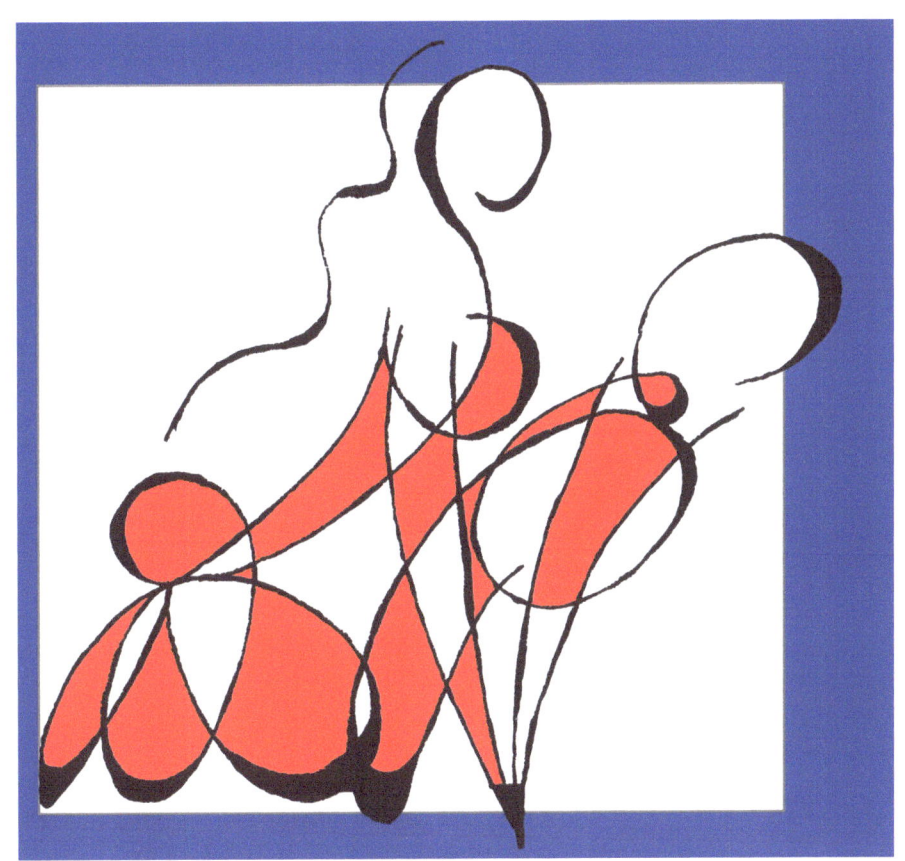

Hassan Abeida

Destiny
2565 pixels x 1957 pixels

Colors Of My Feels

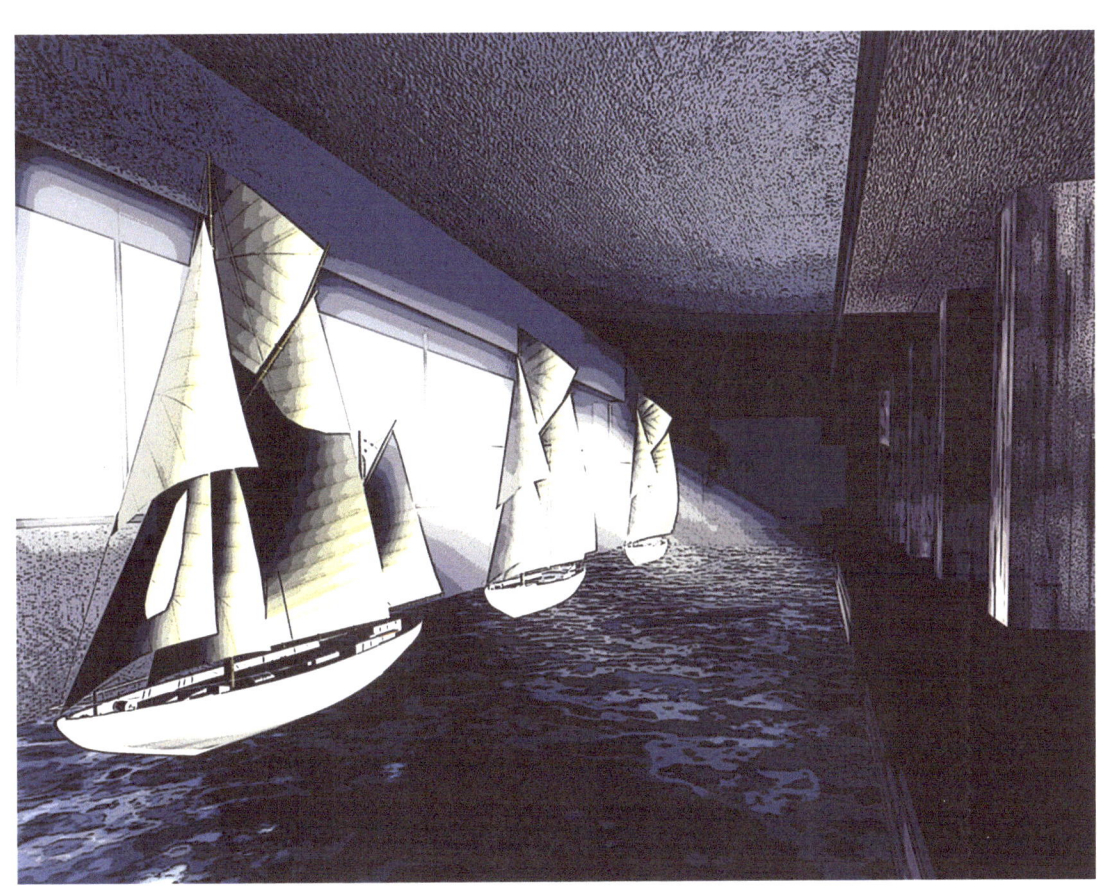

Hassan Abeida

Hopeless Look
3150 pixels x 3039 pixels

Colors Of My Feels

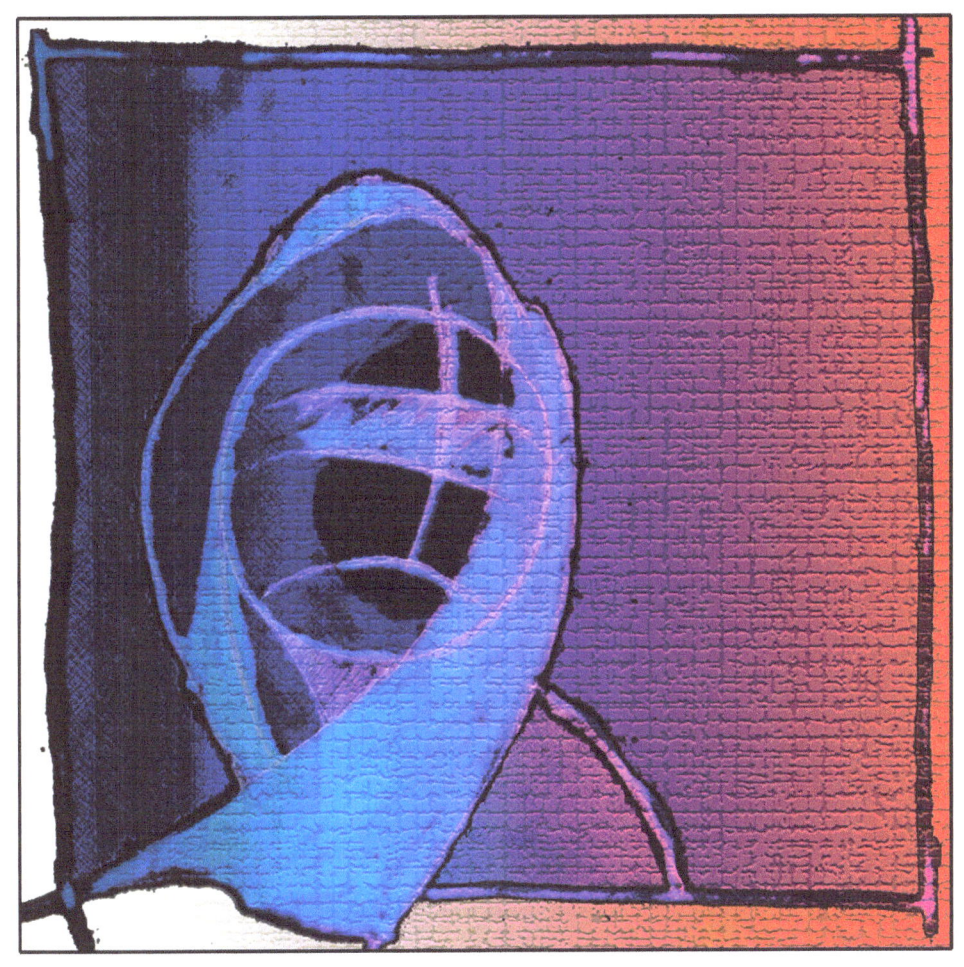

Hassan Abeida

Temptation
1148 pixels x 1459 pixels

Colors Of My Feels

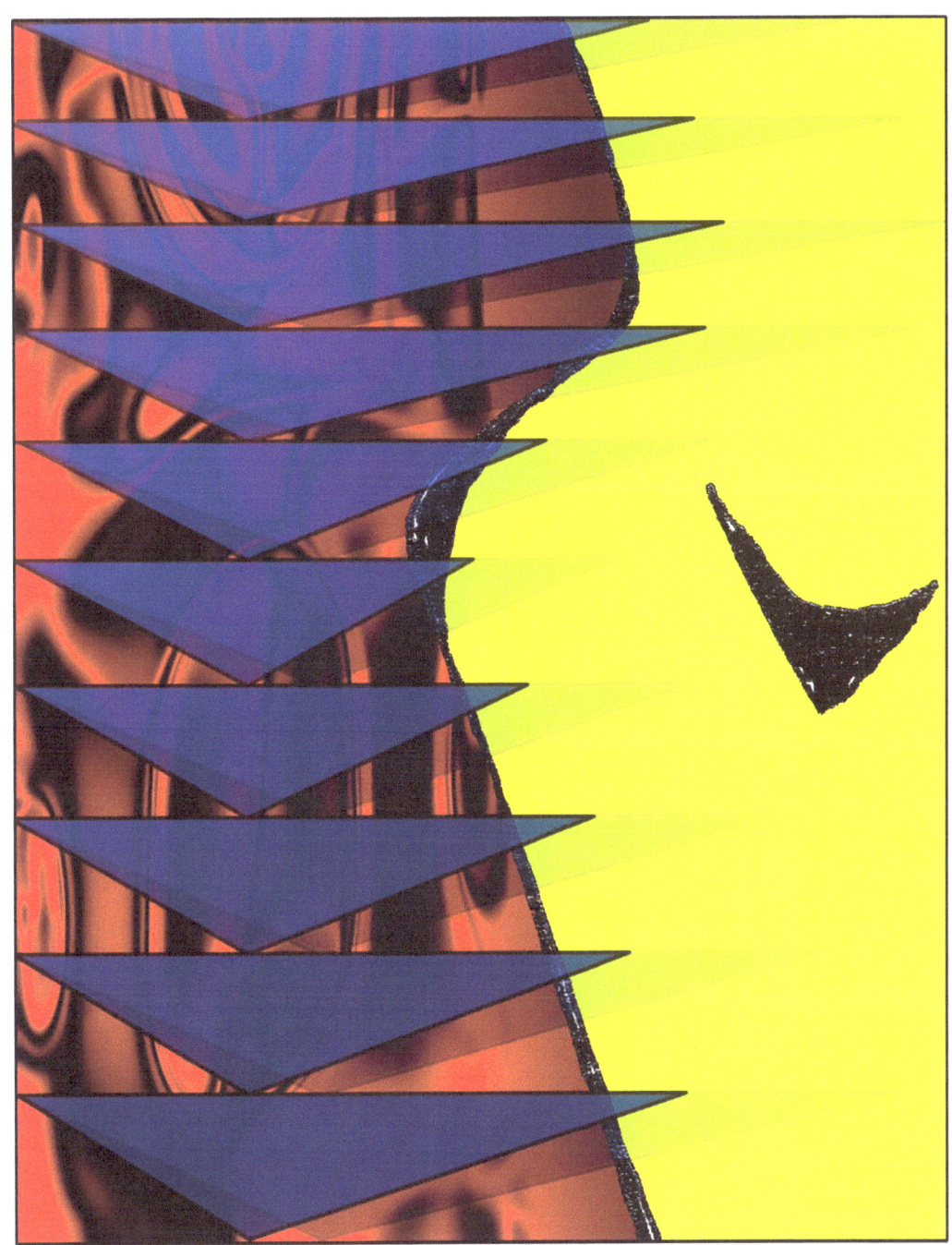

Hassan Abeida

Continues Repress
1575 pixels x 2168 pixels

Colors Of My Feels

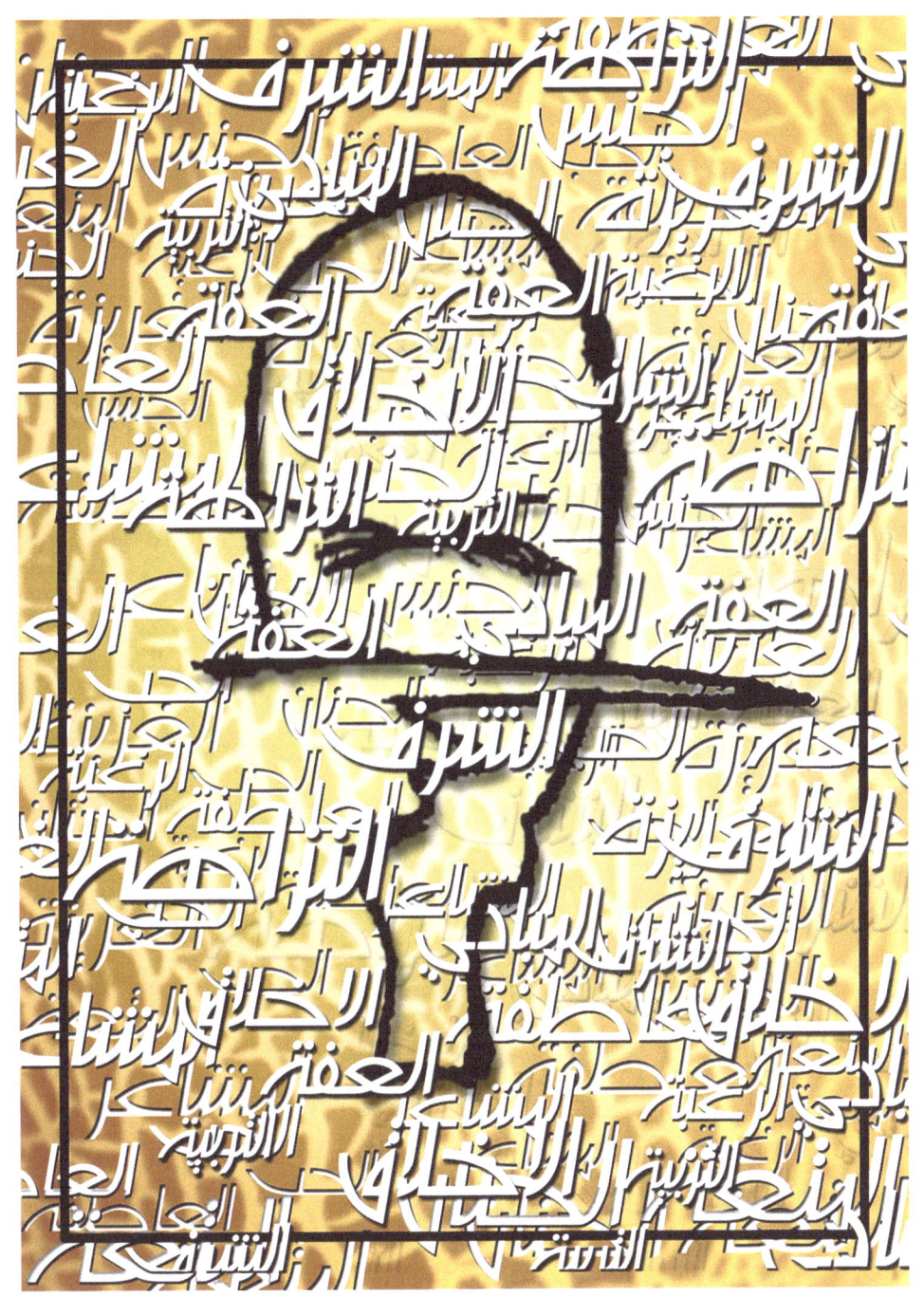

Hassan Abeida

Fuzzy Mind
1600pixels x 1200 pixels

Colors Of My Feels

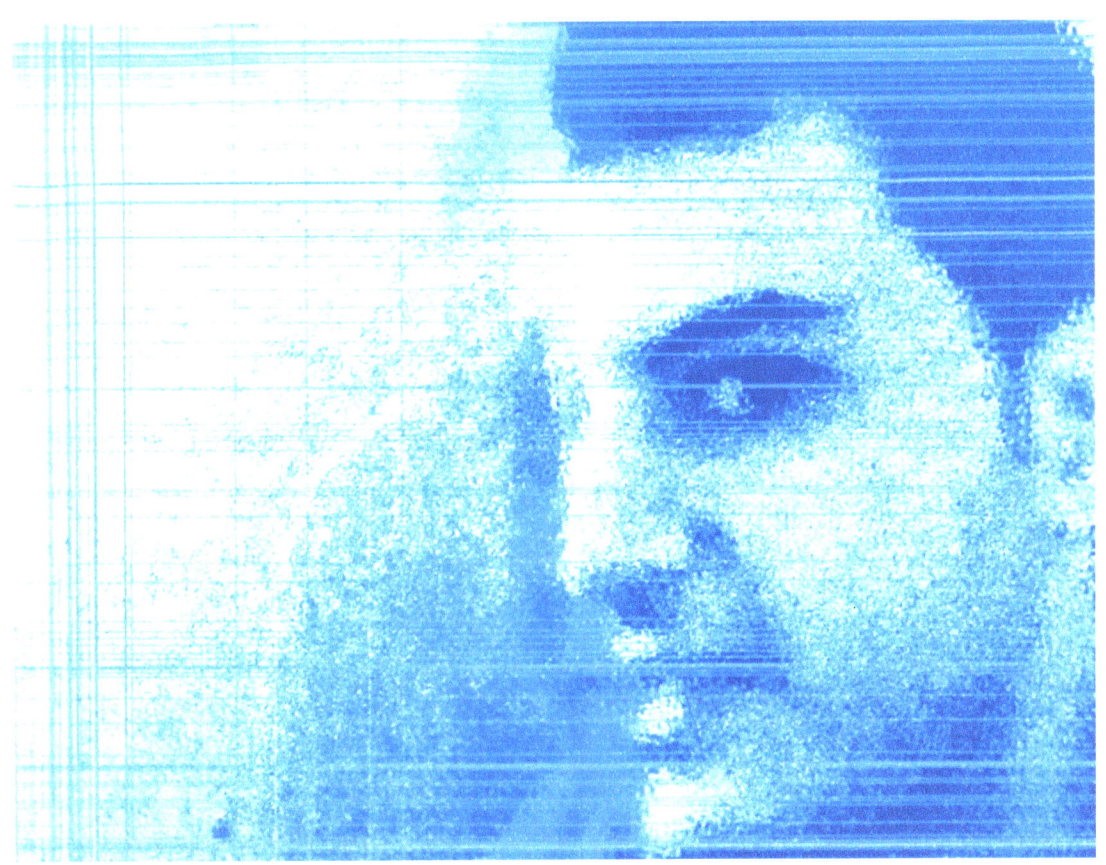

Hassan Abeida

Thinking
1738 pixels x 1871 pixels

Colors Of My Feels

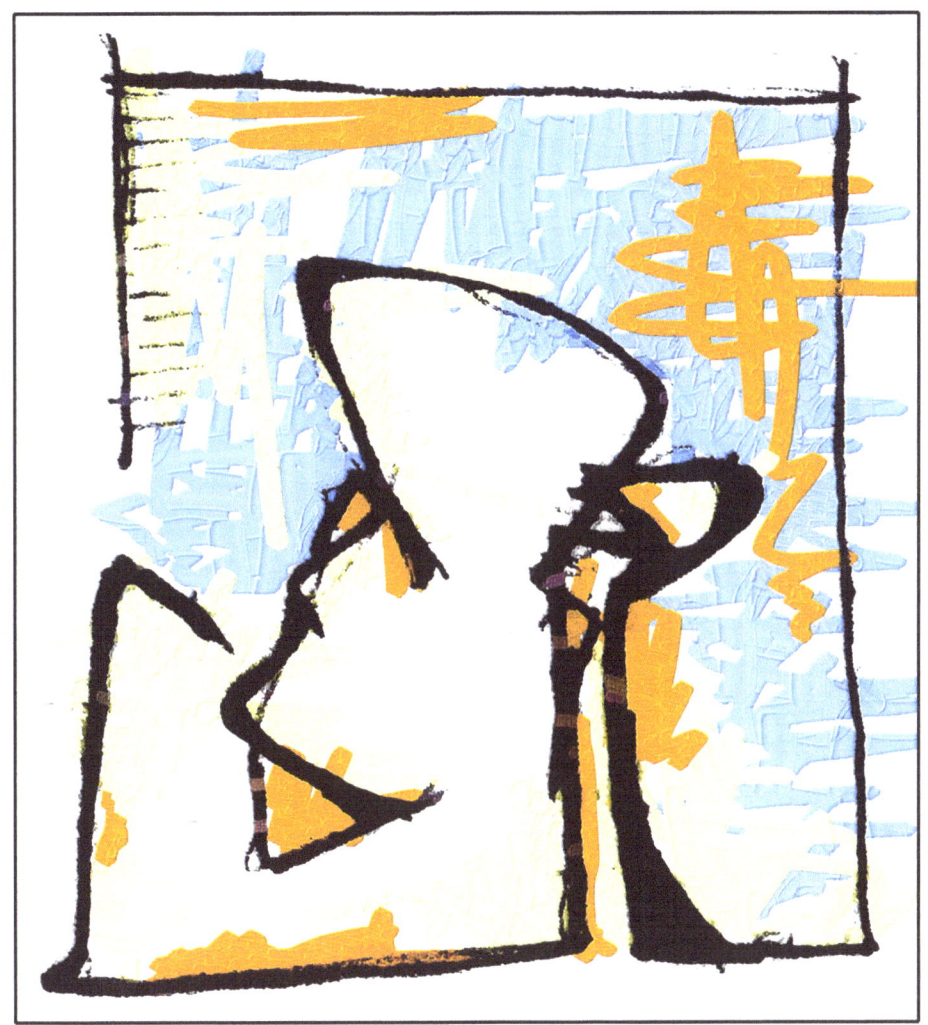

Hassan Abeida

Colors Of Experience
1701 pixels x 2048 pixels

Colors Of My Feels

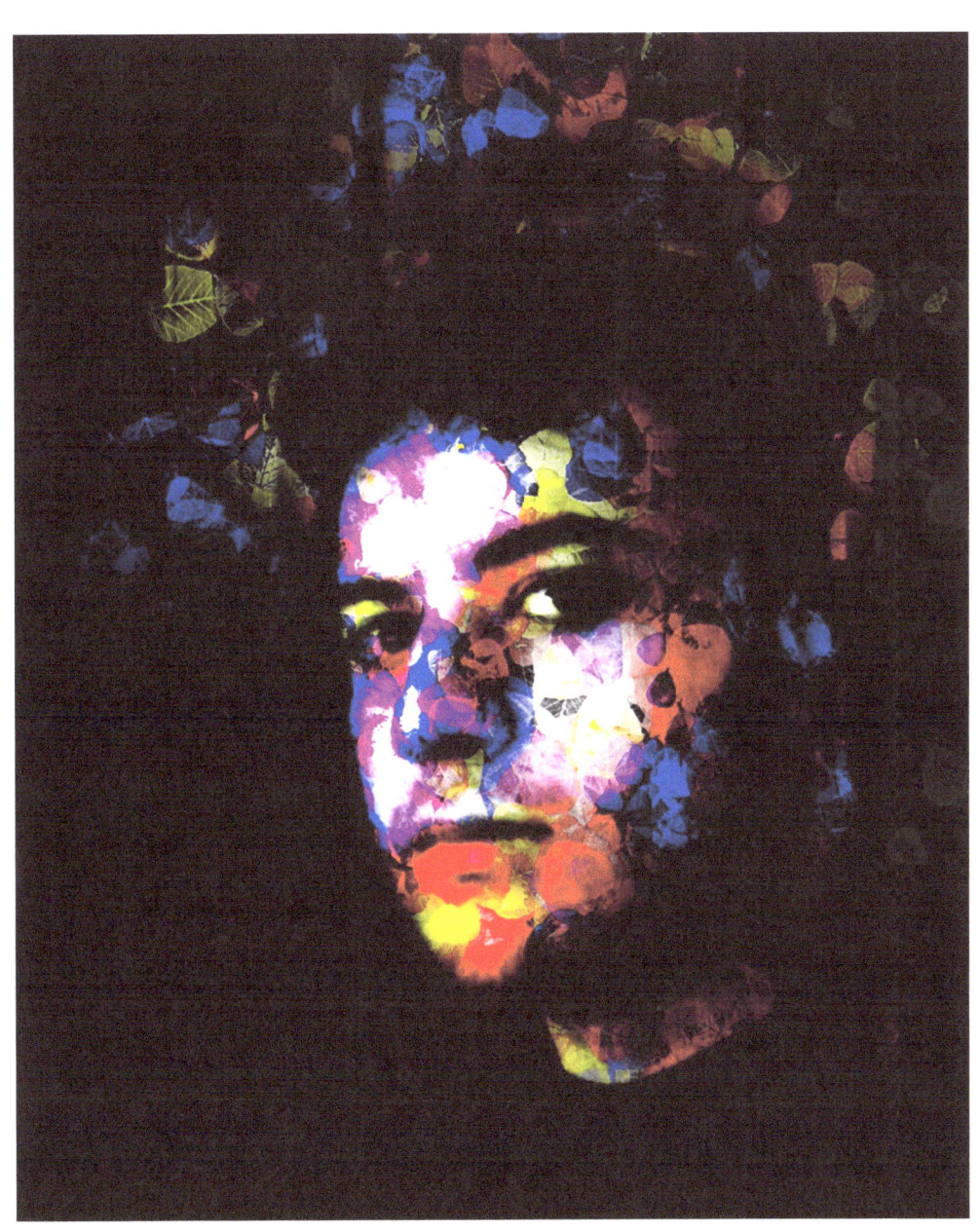

Hassan Aboida

What Is All About !
1543 pixels x 1568pixels

Colors Of My Feels

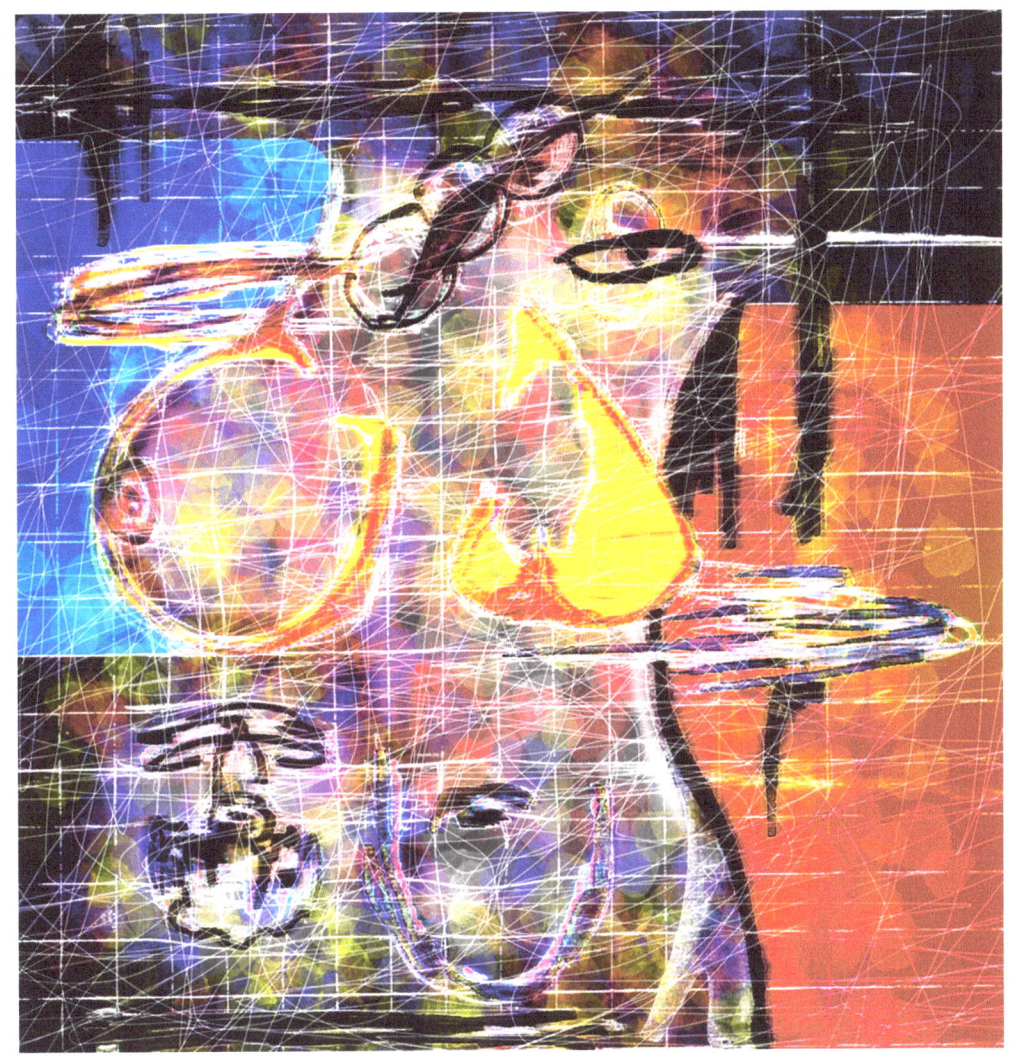

Hassan Abeida

Body & Soul
2709 pixels x 1354 pixels

Colors Of My Feels

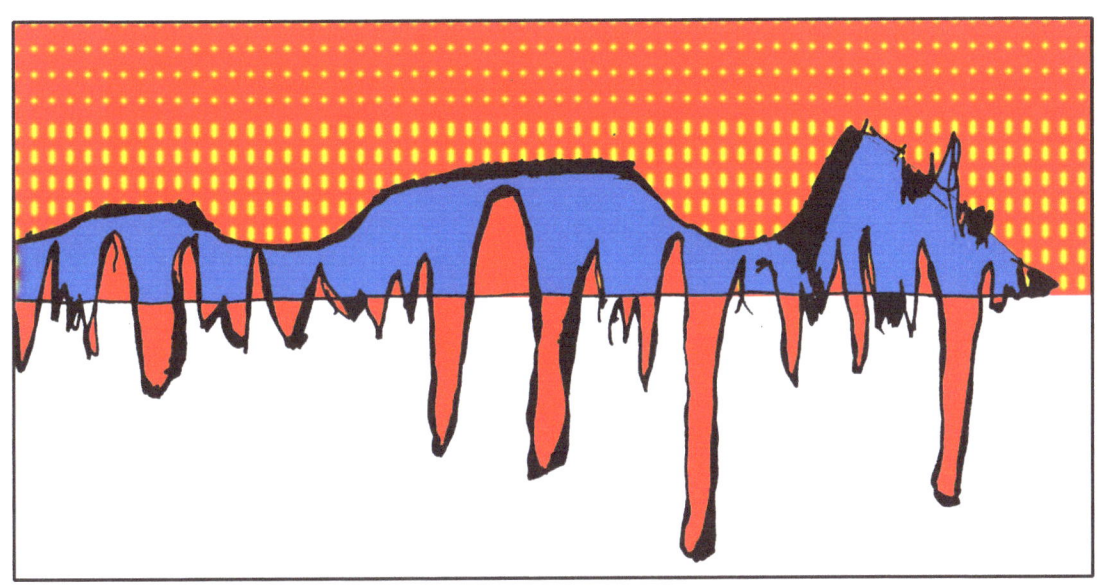

Hassan Abeida

Regret
3150 pixels x 3320 pixels

Colors Of My Feels

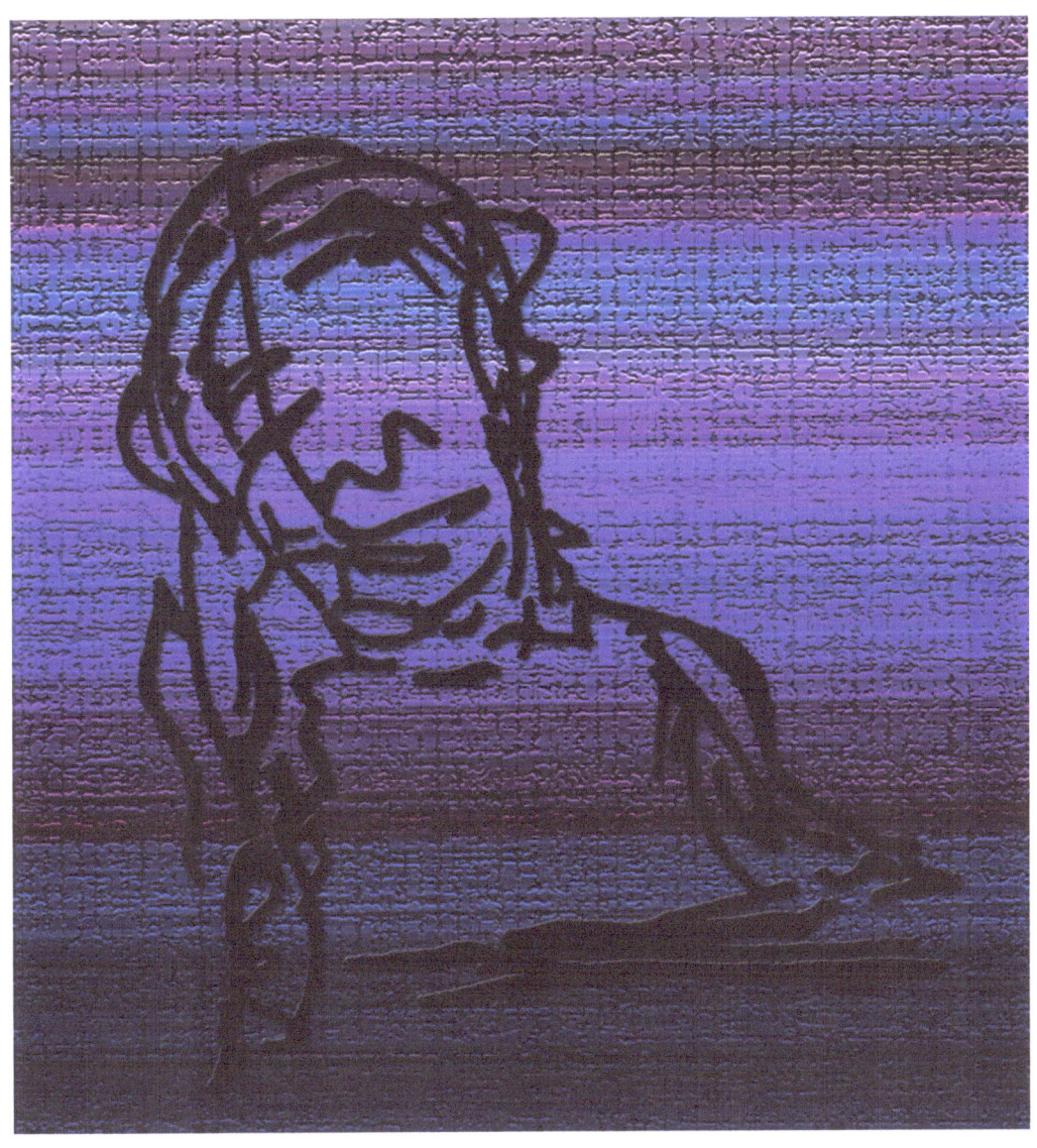

Hassan Abeida

Mountains Of Joy
4724 pixels x 1826 pixels

Colors Of My Feels

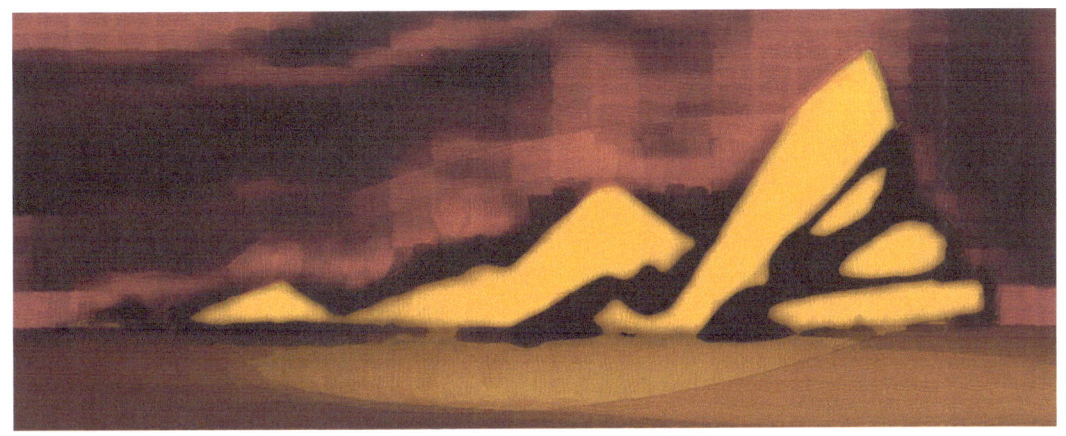

Hassan Abeida

Summer Night
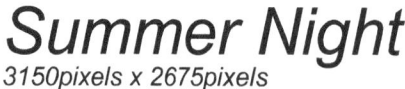
3150pixels x 2675pixels

Colors Of My Feels

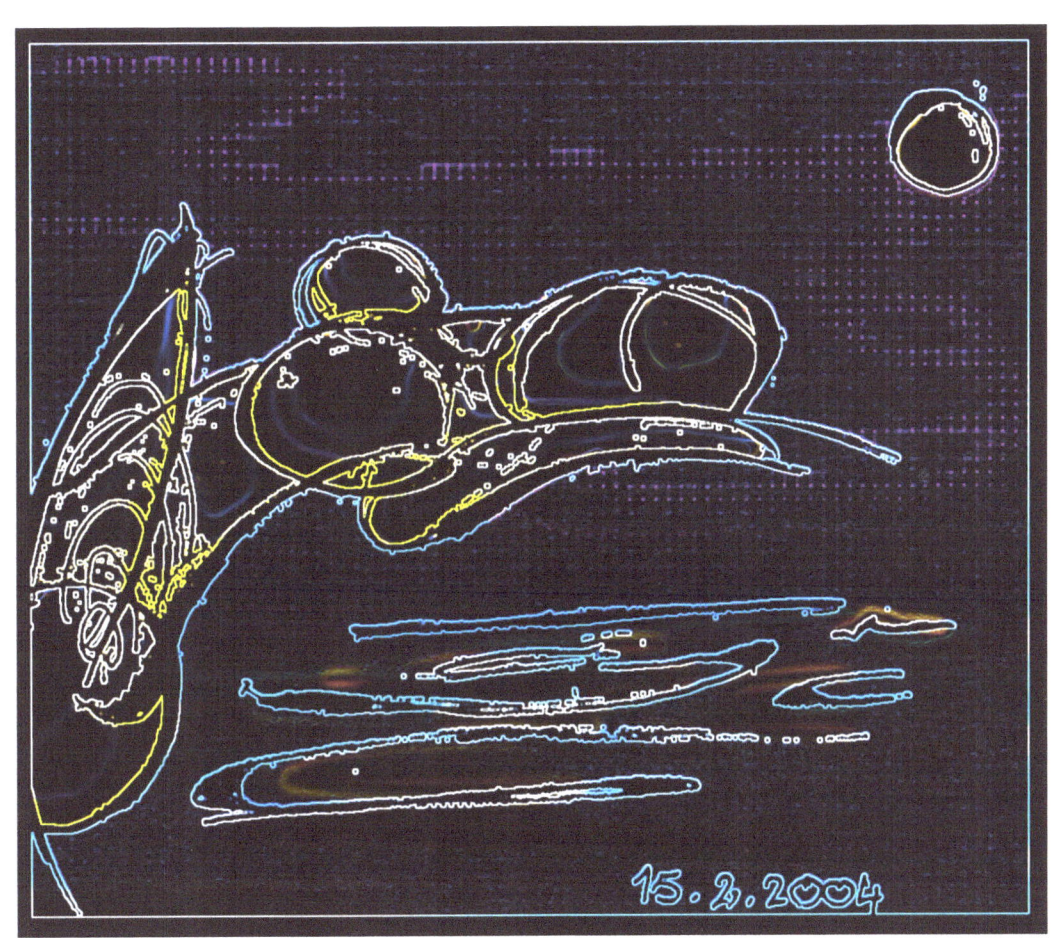

Hassan Abeida

Telepathy
1575 pixels x 886 pixels

Colors Of My Feels

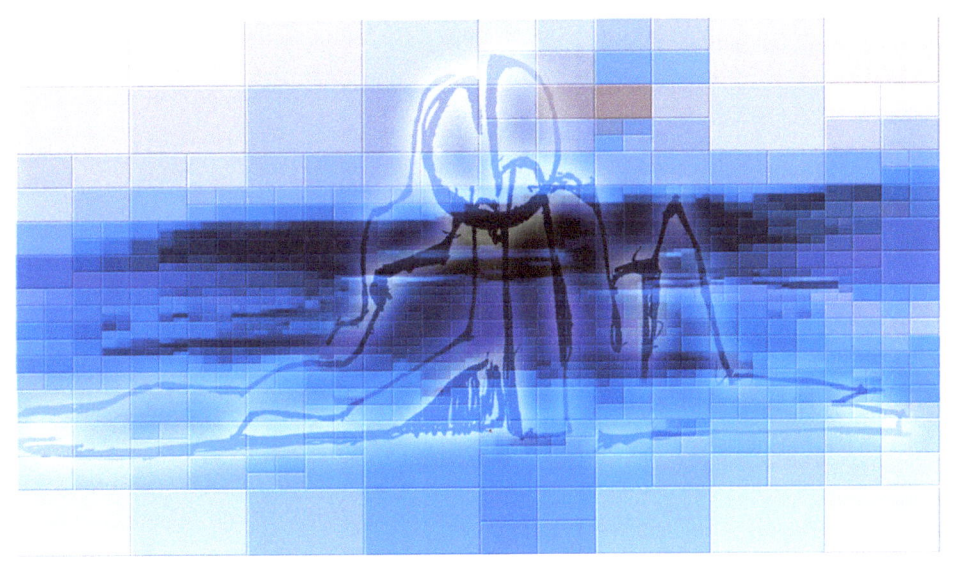

Hassan Abeida

Ignorance
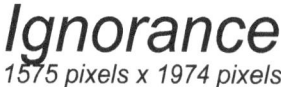
1575 pixels x 1974 pixels

Colors Of My Feels

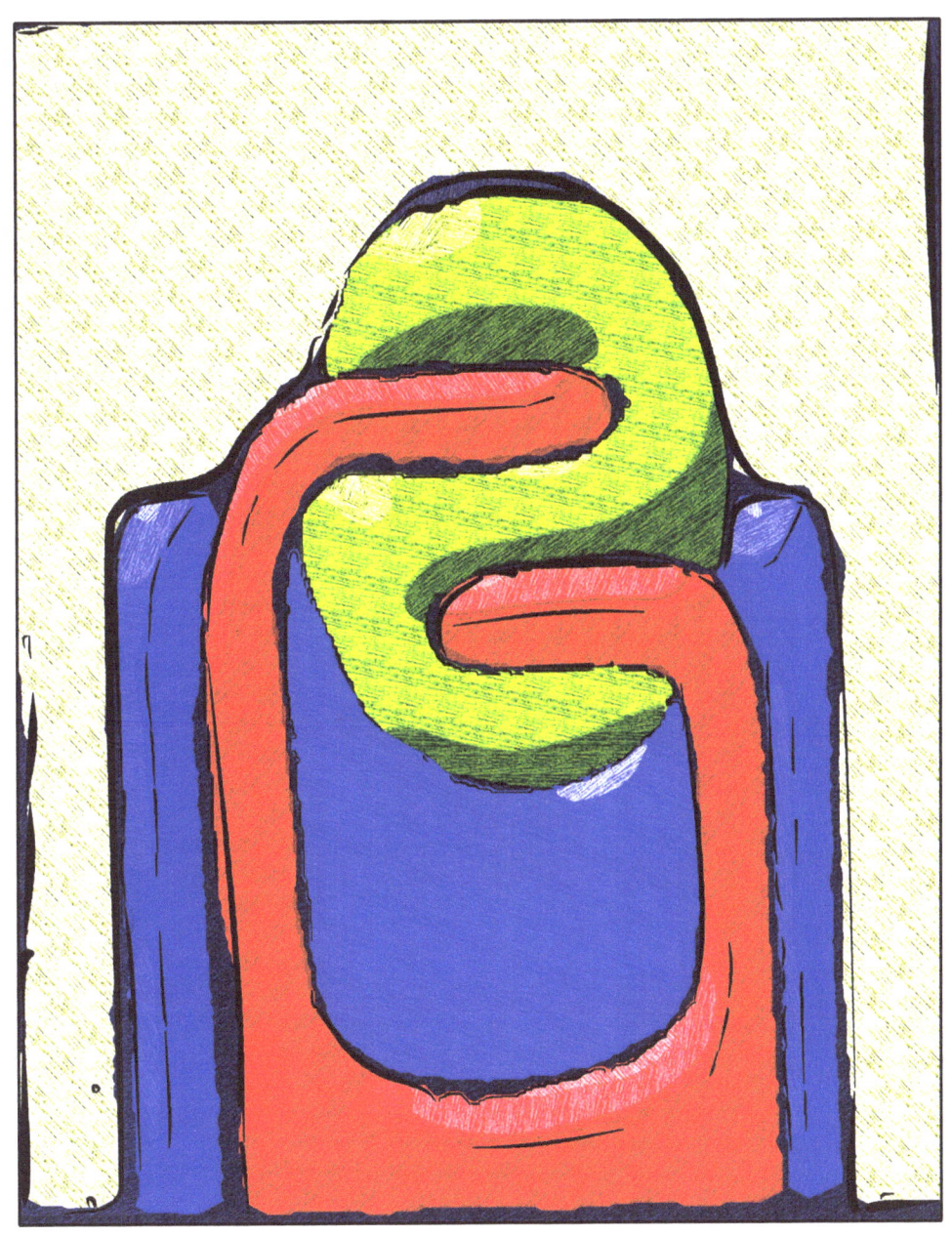

Hassan Abeida

Brush's voice
1575 pixels x 2587 pixels

Colors Of My Feels

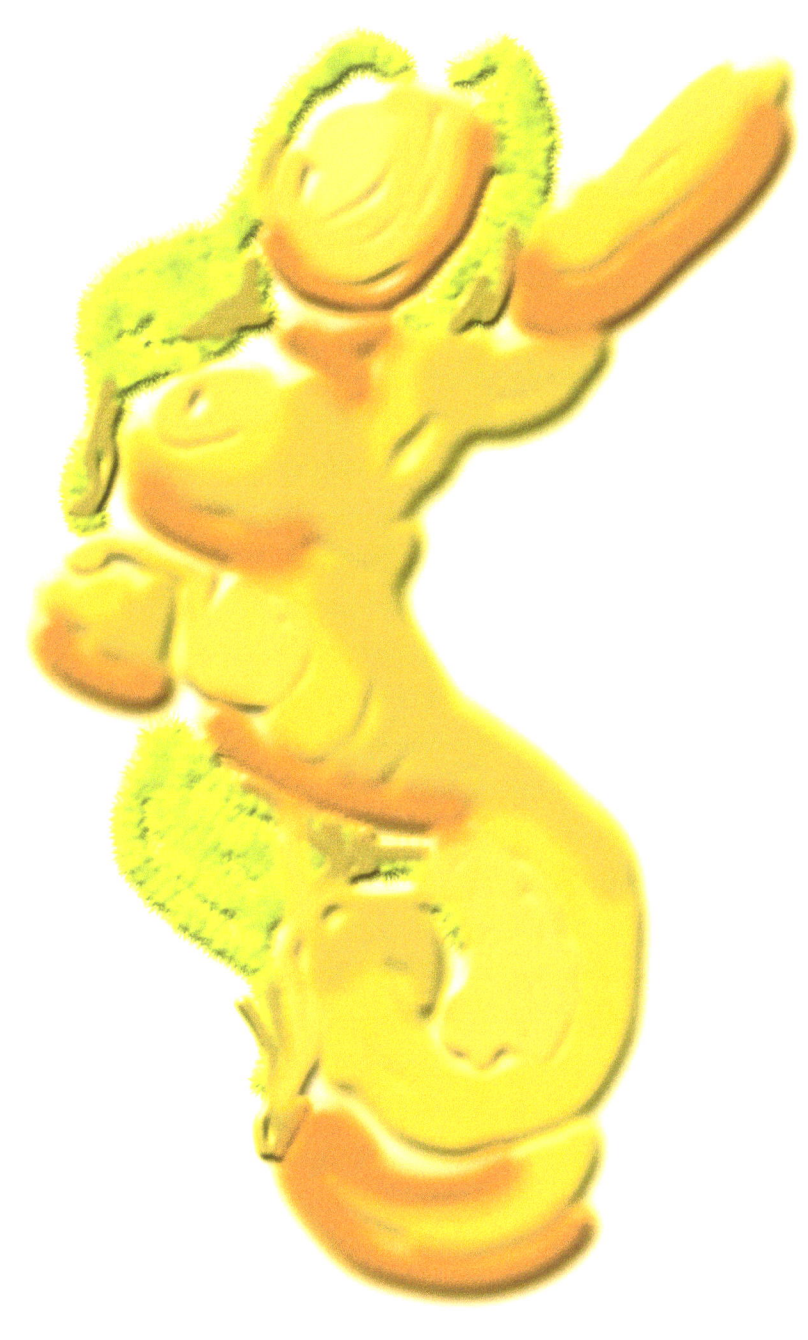

Hassan Abeida

In The Dark
3196 pixels x 5118 pixels

Colors Of My Feels

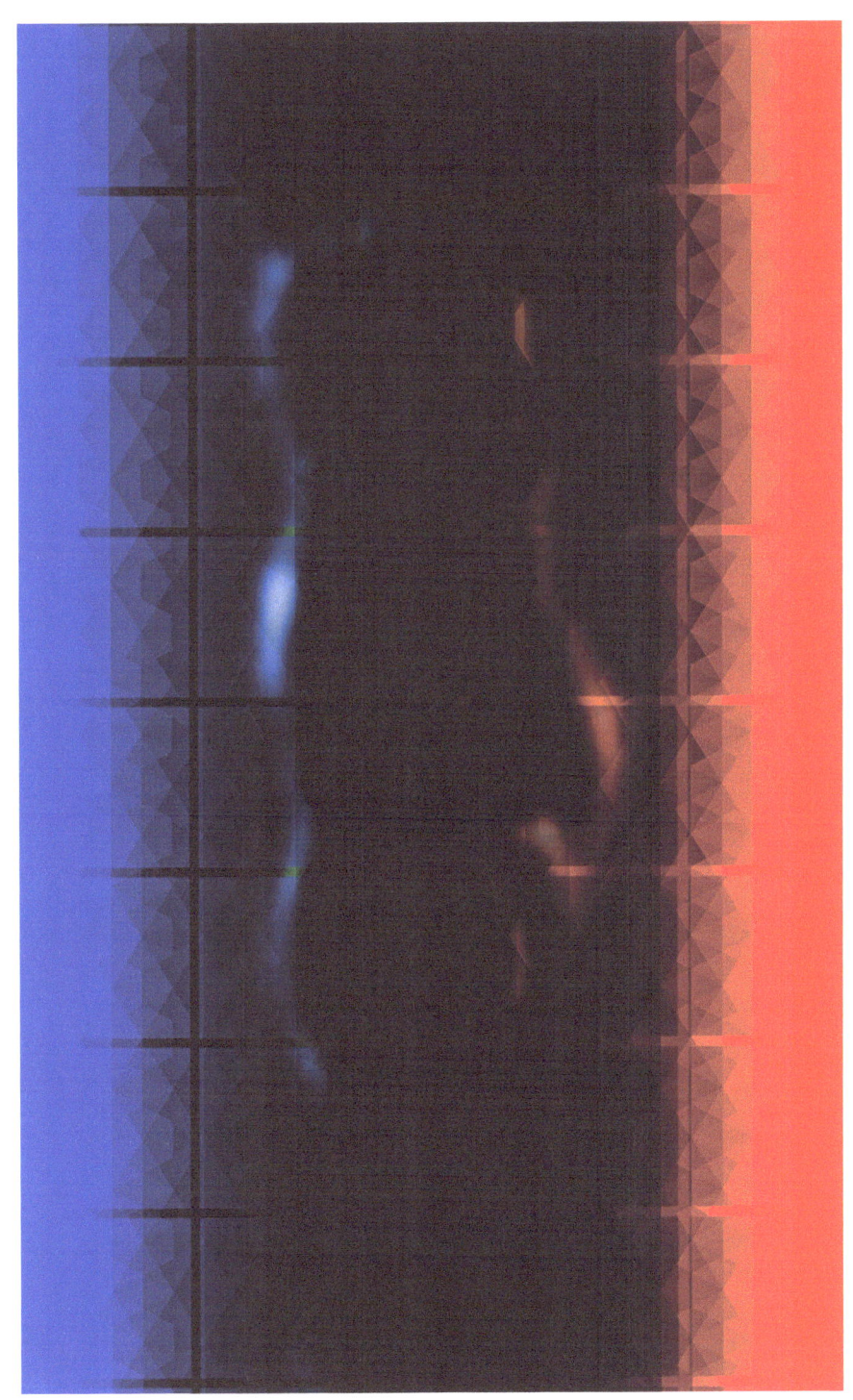

Hassan Abeida

*Look & You Will Know
What Is It Inside*
4724 pixels x 6123 pixels

Colors Of My Feels

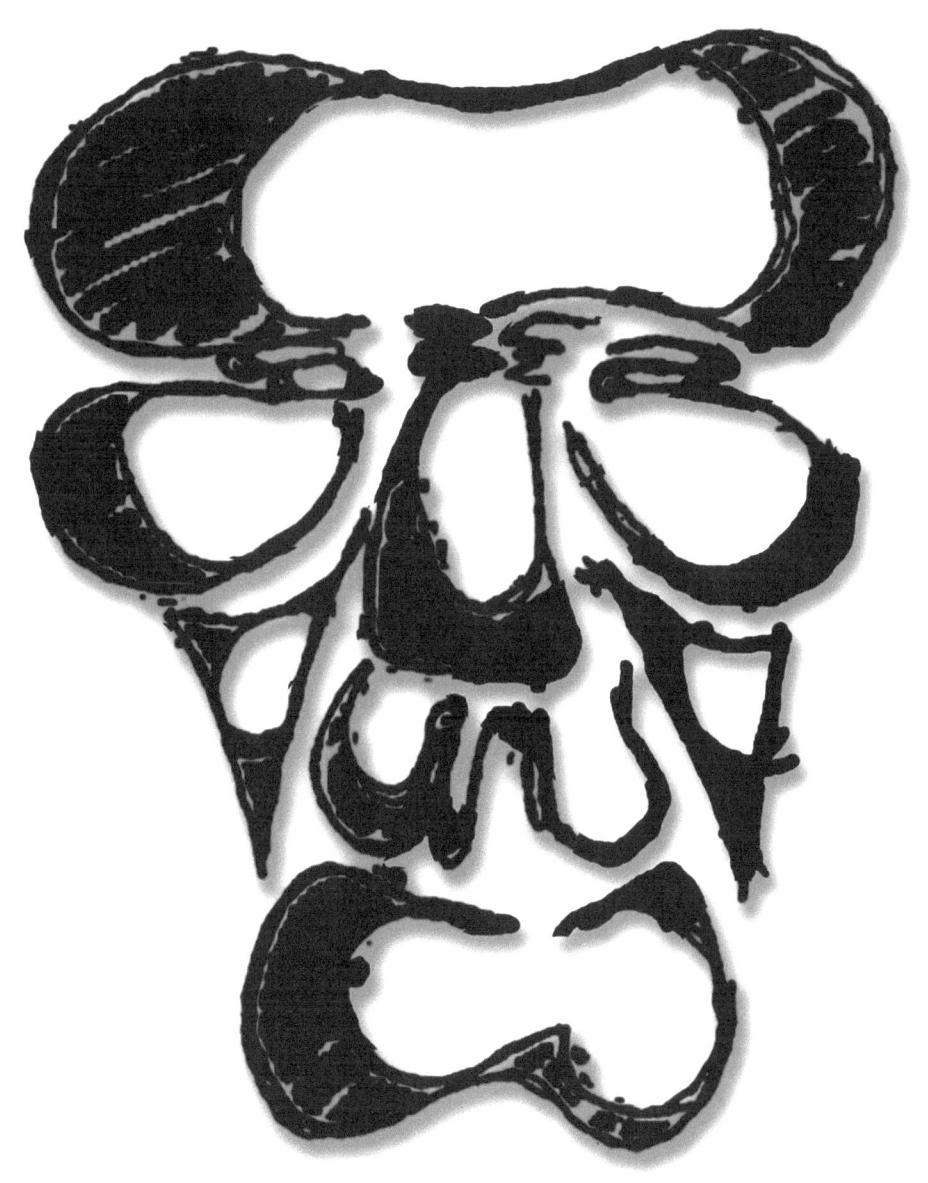

Hassan Abeida

Can Not
446 pixels x 440pixels

Colors Of My Feels

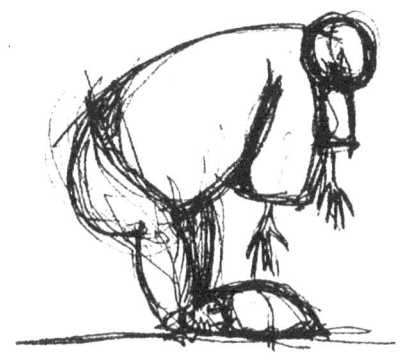

Hassan Abeida

B14
1654 pixels x 1169 pixels

Benghazi city in 2014 , civil war ,trash everywhere , the zoo attacked and the animals escaped , monkeys run in the streets of the city ,dark , no electricity and everybody repeating the same shit again and again

Colors Of My Feels

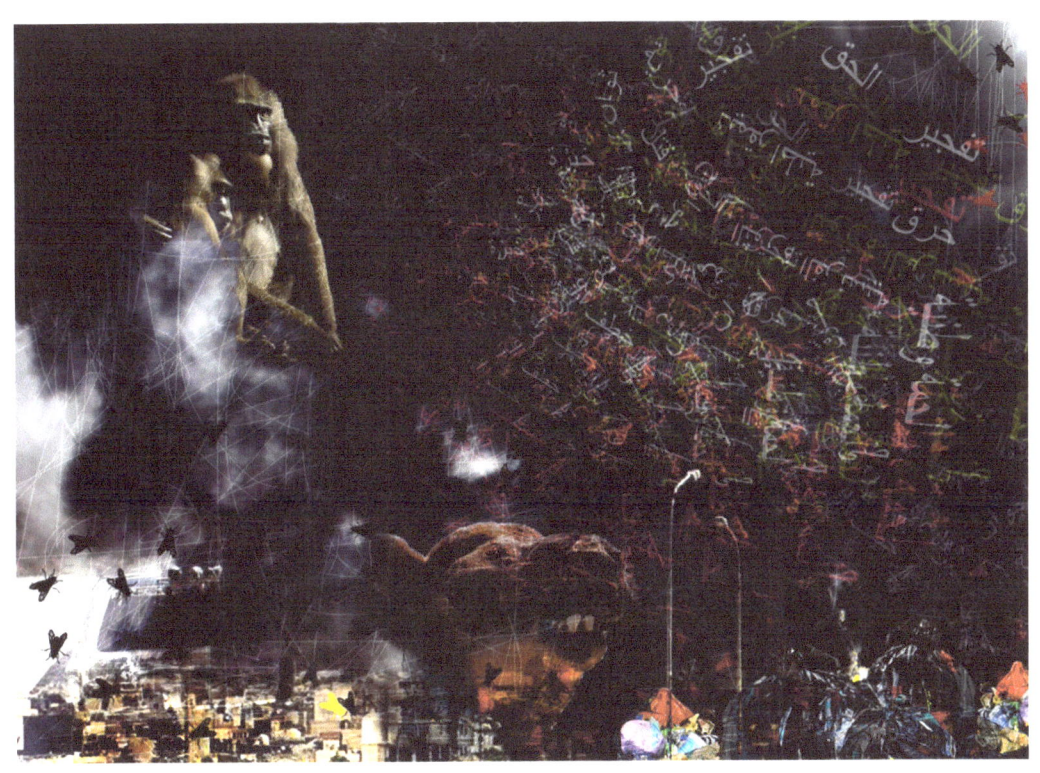

Hassan Abeida

Resistance
1500 pixels x 1125 pixels

Colors Of My Feels

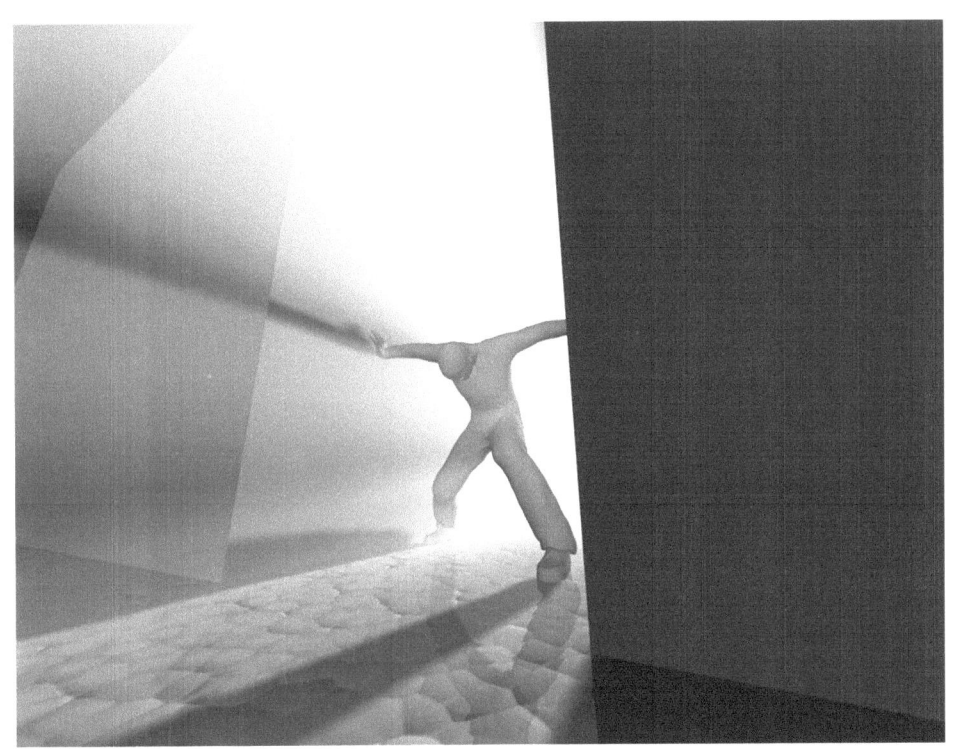

Hassan Abeida

Basic & Projection
640pixels x 480pixels

Colors Of My Feels

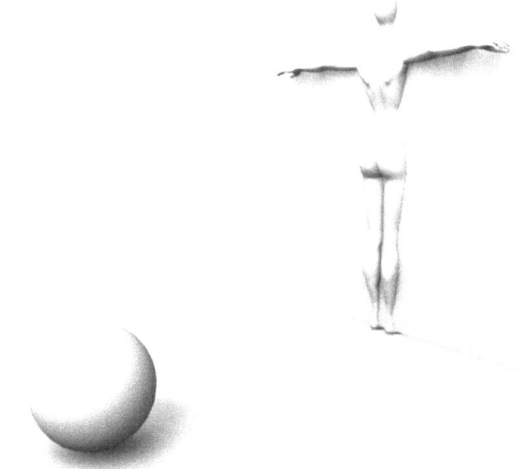

Hassan Abeida

Relativity
1804 pixels x 2049 pixels

"An hour sitting with a pretty girl on a park bench passes like a minute, but a minute sitting on a hot stove seems like an hour."
Albert Einstein

Colors Of My Feels

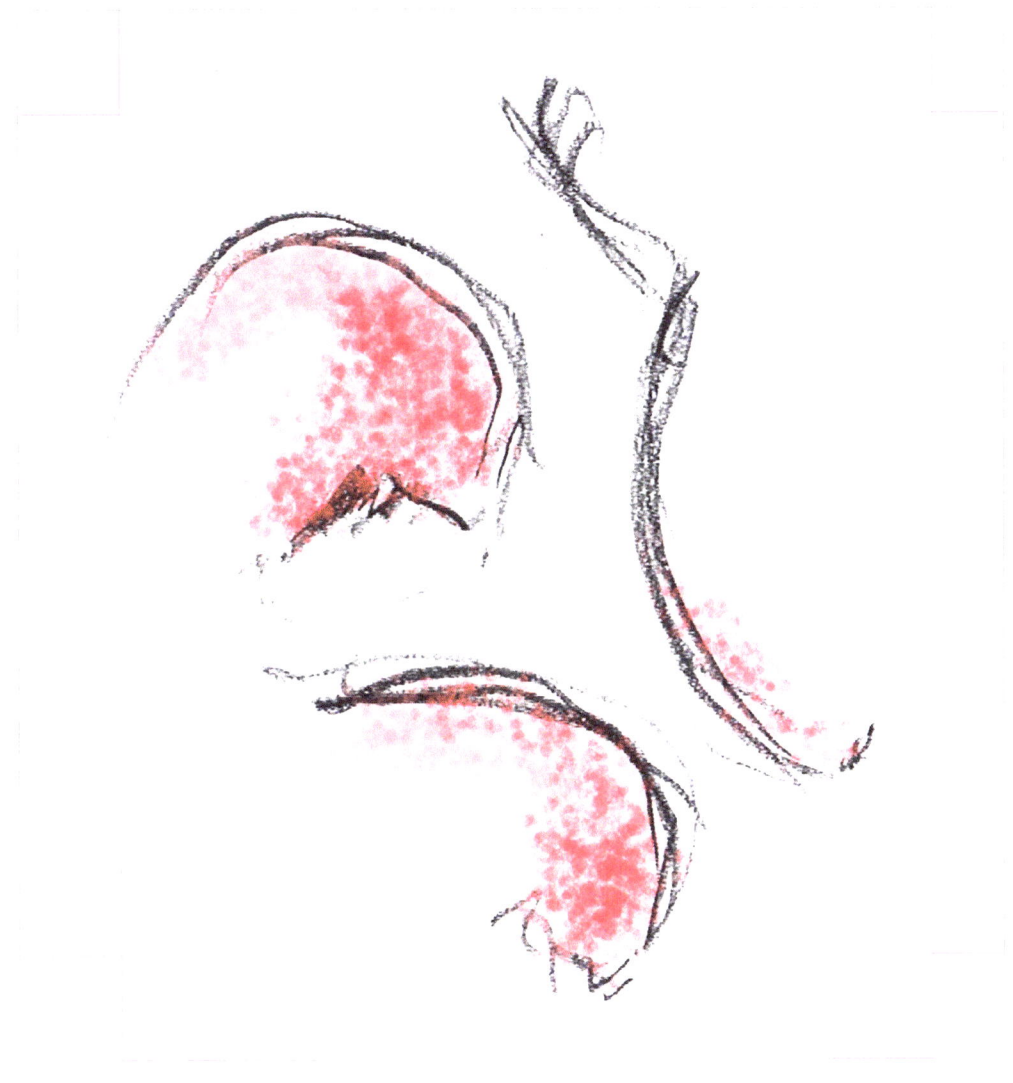

Hassan Abeida

Contents

Human Beings	10
Greed	12
Ice & Fire	14
Fear & Motherliness	16
It's Now !	18
Destiny	20
Hopeless Look	22
Temptation	24
Continues Repress	26
Fuzzy Mind	28
Thinking	30
Colors Of Experience	32
What Is All About !	34
Body & Soul	36
Regret	38
Mountains Of Joy	40
Summer Night	42
Telepathy	44
Ignorance	46
Brush's voice	48
In The Dark	50
Look & You Will Know	
What Is It Inside	52
Can Not	54
B14	56
Resistance	58
Basic & Projection	60
Relativity	62

www.ingramcontent.com/pod-product-compliance
Lightning Source LLC
Chambersburg PA
CBHW041315180526
45172CB00004B/1109